David Hayes: Vertical Motifs
at the Mobile Museum of Art

ISBN 1-893174-05-0

David Hayes: Vertical Motifs
at the Mobile Museum of Art

December 2004 to January 2006

4850 Museum Drive
Mobile, AL 36608 USA
(251) 208-5200
www.mobilemuseumofart.com

ISBN 1-893174-05-0

AN APPRECIATION

A FAMILY OF SOLITARY SENTINELS. A black and white photograph of an earlier installation of David Hayes' *Vertical Motif Series,* pictured in a landscape of snow and silence, inspired the idea for an exhibition of this series of sculptures, a first presentation of his work in this region of the American landscape. Obviously, short of special effects, in a semi-tropical setting like Mobile's, an exhibition here could be suggestive only in other ways. The most successful sculptural projects of the past are those which have been responsive to the site and are designed to calculatedly anticipate interaction with a viewer. Sometimes the space given to an artist is challenging. Fortunately, the landscape plan of the new Mobile Museum of Art (2002), established a site along the Vaughan Morrissette Sculpture Trail that was open to possibilities; it became clear that the space offered the opportunity to present what is virtually a thirty year retrospective of Hayes' *Vertical Motif Series* that began in 1976.

Since the late 19th century, the exploration of a theme in a series has been attractive to artists and especially so since the 1950s. Seen together, it is almost as though the series is the subject, although the idea and each piece can be appreciated independently. It has been a particularly popular concept among painters and printmakers. Perhaps, the especially lengthy creative process the sculptor faces lends itself less well to such an approach, or a least fewer works find their way to completion. This 2005 installation in Mobile presents a particularly unique opportunity to see an artist's fully realized dialogue within a set of conceptual and formal restrictions.

From the first to the last, these sculptures, dating from 1976 to 2005, are entirely works of Hayes' maturity and resist an analysis that might deal with issues of change or development. If anything, they demonstrate how well Hayes has established subtle compositional combinations of vertical and planar elements that give each piece a visual variety. Hesitantly, one might even say a personality. They belong to a conceptual family. Uniting them all and clearly a major component of their aesthetic is the observable truth that they emanate from an imagination that instinctively preconceives form in space, however much drawing and models are maintained as helpmates in the process.

Totem, semaphore, figure or tree – Hayes has chosen to work with significant shapes that are at once familiar and suggestive, but always gestural, seemingly animated by an unseen wind. And while these sculptures are present in real time, one recognizes that they simultaneously occupy a dream time belonging to a parallel poetic reality in a strange landscape of deep space and exaggerated shadow. In keeping with their mutability of form, their construction is noteworthy. Their assembly involves a shaped vertical element bolted to a rectangular or circular base. The planar elements are attached to projecting flanges by bolts. The material is mild steel and irregularities of cutting the shapes are maintained, providing a certain organic aspect to what is otherwise rather industrial. Generally the surface is smooth, but on occasion a long welder's bead or the actual repeated pattern of steel decking provides individuality to the sculpture. Their matter of fact assembly proclaims the importance of idea over precious object. Uniformly painted black, these reunited *Vertical Motif* sculptures maintain their lonely vigil awaiting the responsive visitor.

PAUL W. RICHELSON

Assistant Director

LOOKING AT DAVID HAYES

Looking at the series of sculptures that comprise the *Vertical Motif* series, it is remarkable to me how consistent the language of elements and feeling has remained over a period of thirty years. It is certainly a hallmark of a mature and extremely gifted artist to be capable of creating a work such as *Vertical Motif #30* of 2005 that completely retains a youthful vigor and freshness even when compared to the fully realized, muscular works from the mid 70's. It would indeed take someone very familiar with his œuvre or at least highly intuitive to be able to say which ones were produced earlier. This is not to say that the works are static or not evolving. I think it is possible to detect a gentle humor that is becoming more evident. It has been possible for Hayes to explore so many options within this one creative vein because it is such a rich lode.

The subject of these sculptural explorations has remained the exploration of abstract spaces; the play of dense planar masses interacting with the surrounding field through the use of supple inventive line that suggests an organic surrealism wedded to disciplined abstract expressionism. The suggestion of imagery is not entirely avoided; it is just subservient to a rigorous insistence on the heavy metal surface and edge. Given the somewhat human scale of the series, it has taken serious intent to avoid anthropomorphizing the motifs. Nevertheless there are some suggestions of human actions that are present, although these might be found as well in a tree: gracefulness, a sense of pageantry and of motion. A common comparison for abstract works is to music. If these were musical constructions, I would think of jazz, asymmetrical, syncopated and riffing off themes in bursts of succinct creativity.

I am not trying to place these works in an art historical context except as an attempt to understand the artist's ease in maintaining a consistent style through the last several decades. At a time when much sculpture being produced has forked into busy assemblages on the one hand and severe reductions emphasizing the material's nature on the other, Hayes' *Vertical Motif* series continues the ideals of classic modernism through the emphasis on masterful line and massing, it's continued vigor deriving from visual forms seeming to come from the near subconscious, in simpler terms, the imagination. It is Hayes' gift to himself that the manner of his working so continuously feeds his imagination and that that imagination continues to fuel such excellent work.

DONAN KLOOZ
Curator of Exhibitions

NOTES ON VERTICAL MOTIFS

THE MOBILE MUSEUM OF ART EXHIBITION represents a selection of my *Vertical Motif* series, begun in 1976 and continued today. Each Vertical Motif is made from one half inch steel plate, cut with an acetylene torch, then arc welded together. Edges of the finished elements are ground down, then all the pieces are sandblasted and coated with primer paint. Several coats of weather-resistant flat black paint complete the process.

All my sculptures are preceded by ink and gouache drawings on Arches paper. I consider this an integral part of the working process and the drawings themselves are valid works. You will see such drawings in the exhibition.

Macquettes – smaller metal models for sculpture but, again, works in their own right – are here as well, lending yet a different scale to the series.

Primary sources of my imagery come from what I see every day which evoke response and quick pencil sketches of shapes and forms. It is these sketches which translate into colored working drawings, varied colors on the two-dimensional paper representing planes in the eventual three-dimensional piece. I tack these drawings up in my studio and begin making the sculptures.

Interpretations of the sculptures are left to the viewer, subject to their own unlimited fantasies.

DAVID HAYES
Coventry, Connecticut

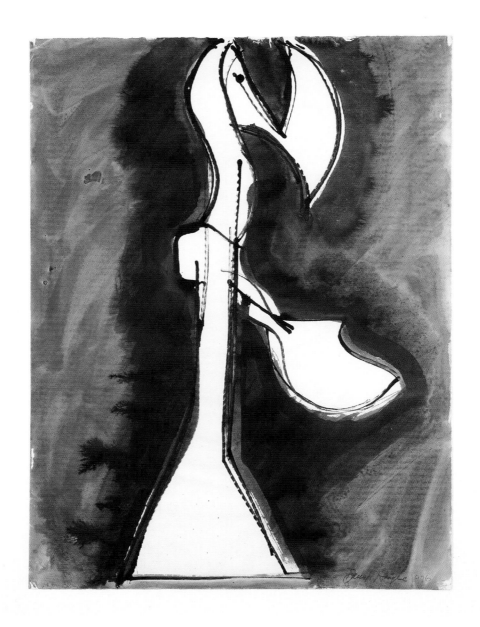

Study for Vertical Motif, 1976. Ink and gouache on paper. 31 × 23.5 inches framed.

Next page: *Vertical Motif #4,* 1976. Welded, painted steel. 100 × 42 × 36 inches.

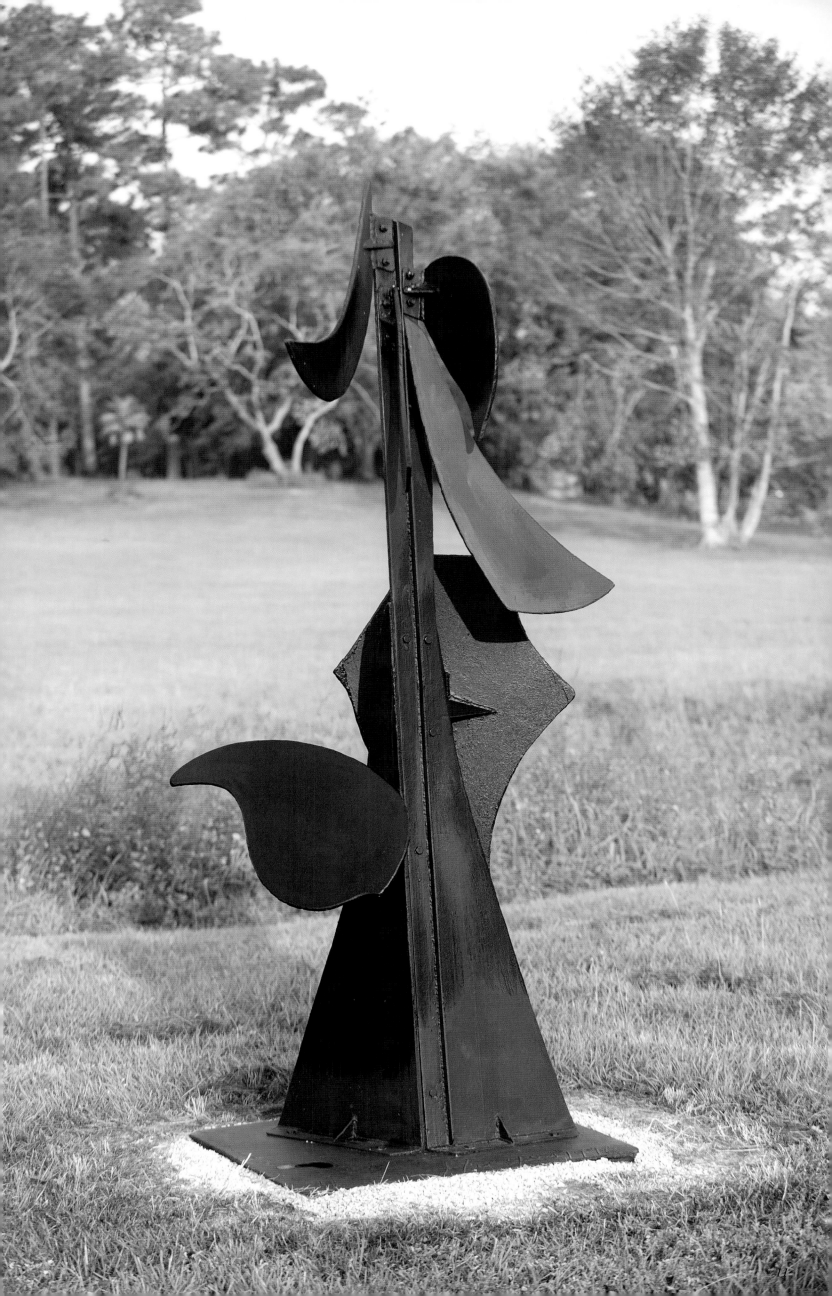

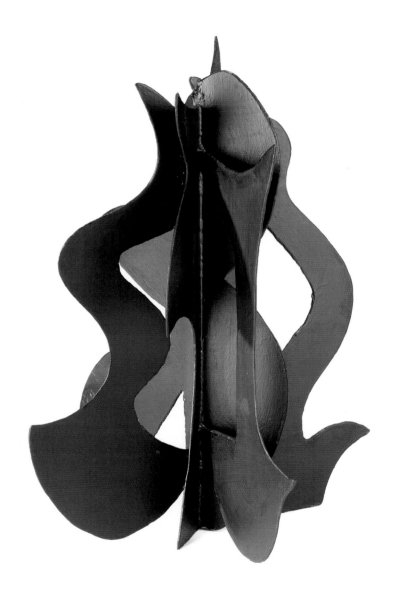

Small Sculpture, 1995. Welded, painted steel. 29.5 × 21 × 21 inches.

Next page: *Vertical Motif #8,* 1977. Welded, painted steel. 113 × 18 × 42 inches.

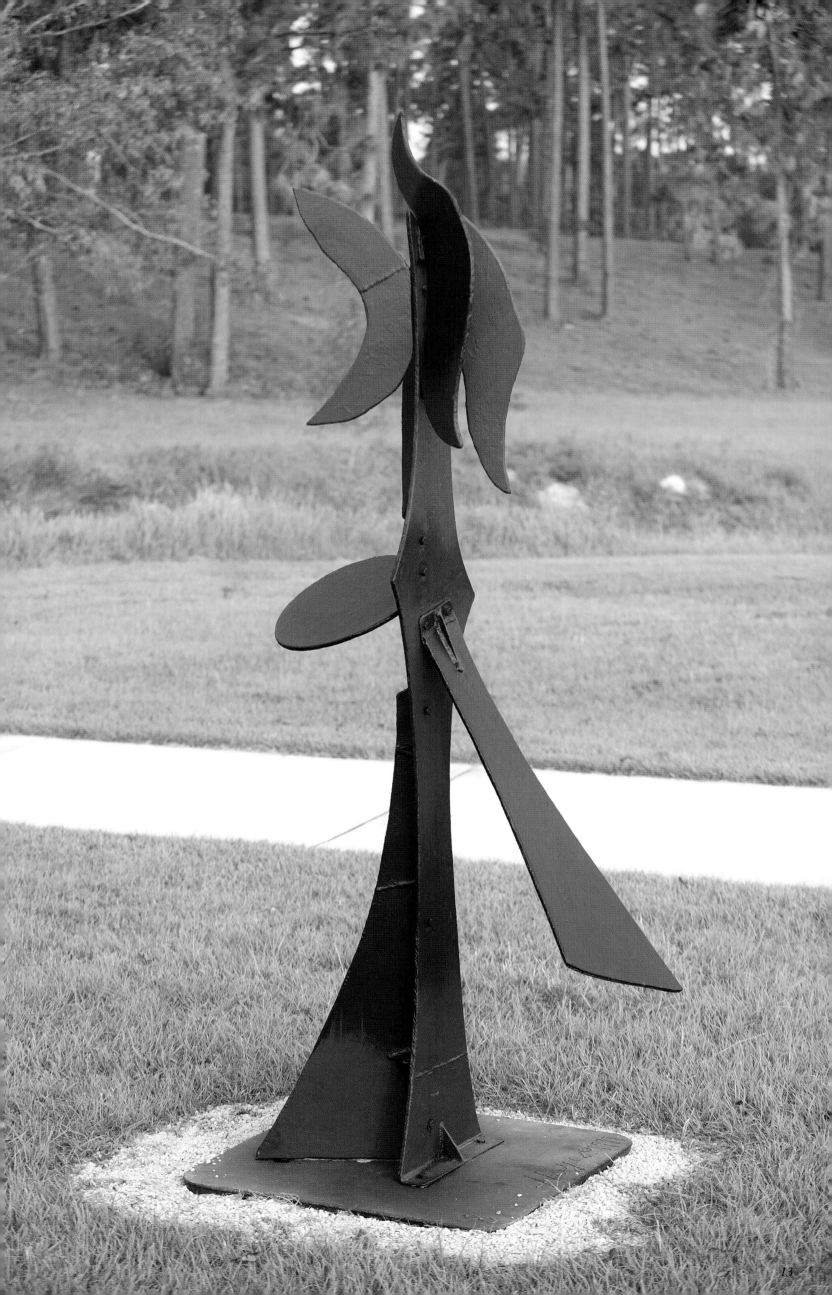

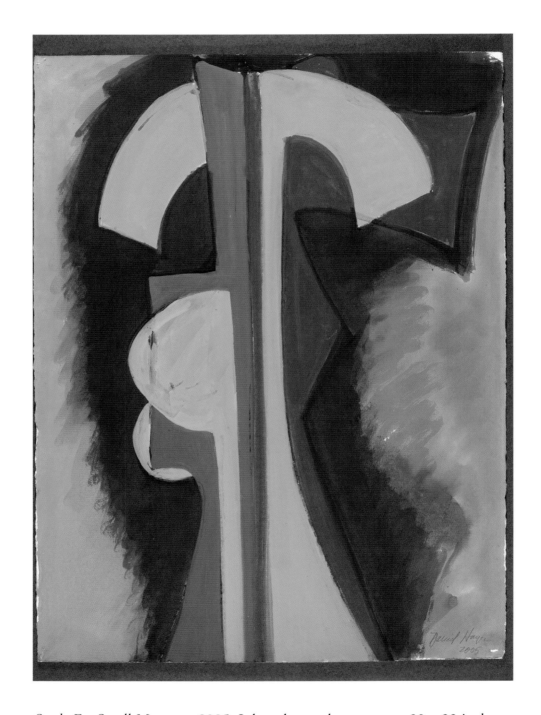

Study For Small Maquette, 2005. Ink and gouache on paper. 30 × 22 inches.

Next page: *Vertical Motif #10,* 1977. Welded, painted steel. 103 × 50 × 36 inches.

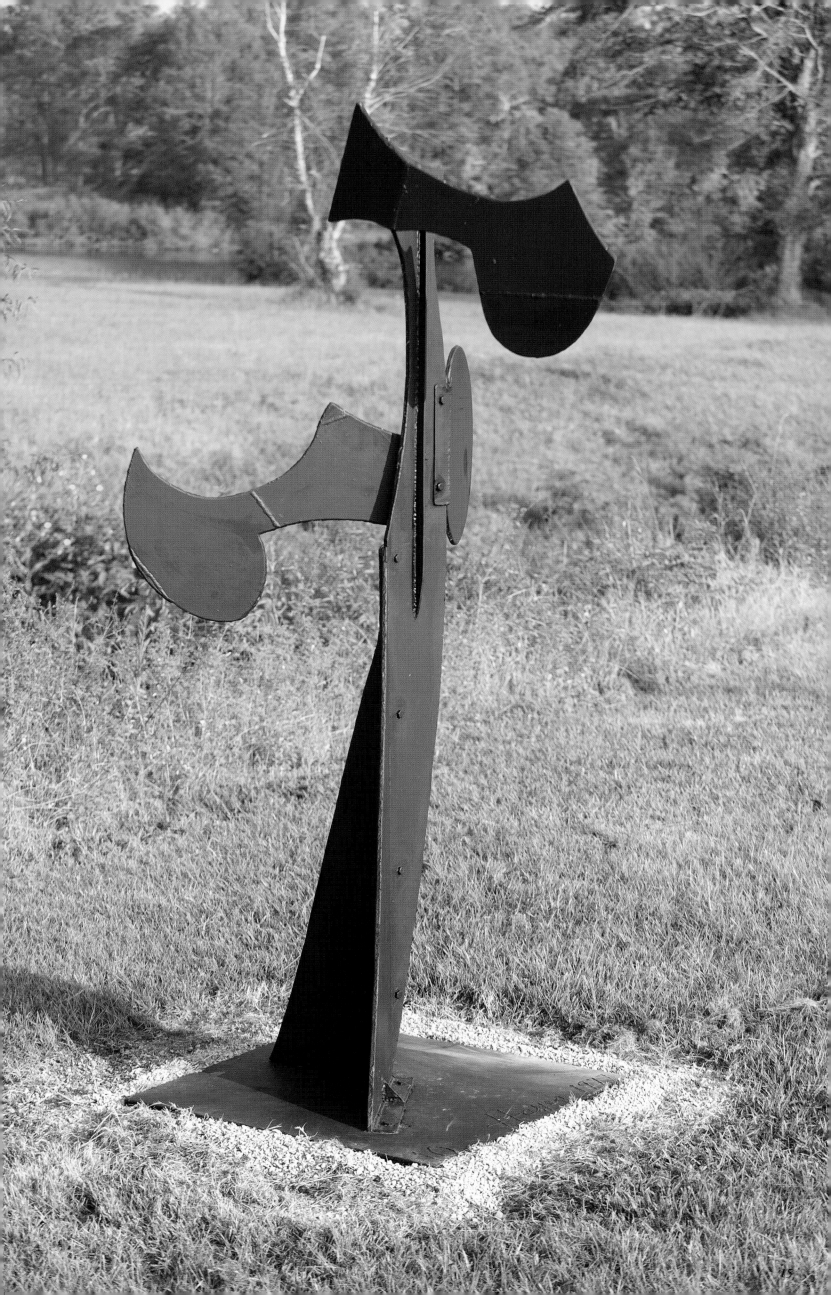

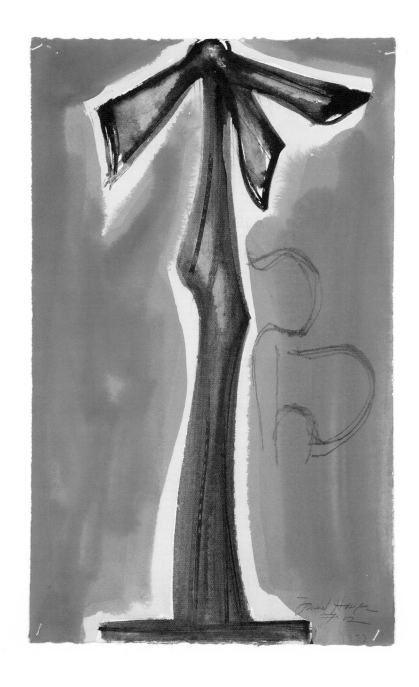

Study for Vertical Motif #12, 1977. Ink and gouache on paper. 27 × 18.25 inches framed.

Next page: *Vertical Motif #12,* 1978. Welded, painted steel. 101 × 48 × 37 inches.

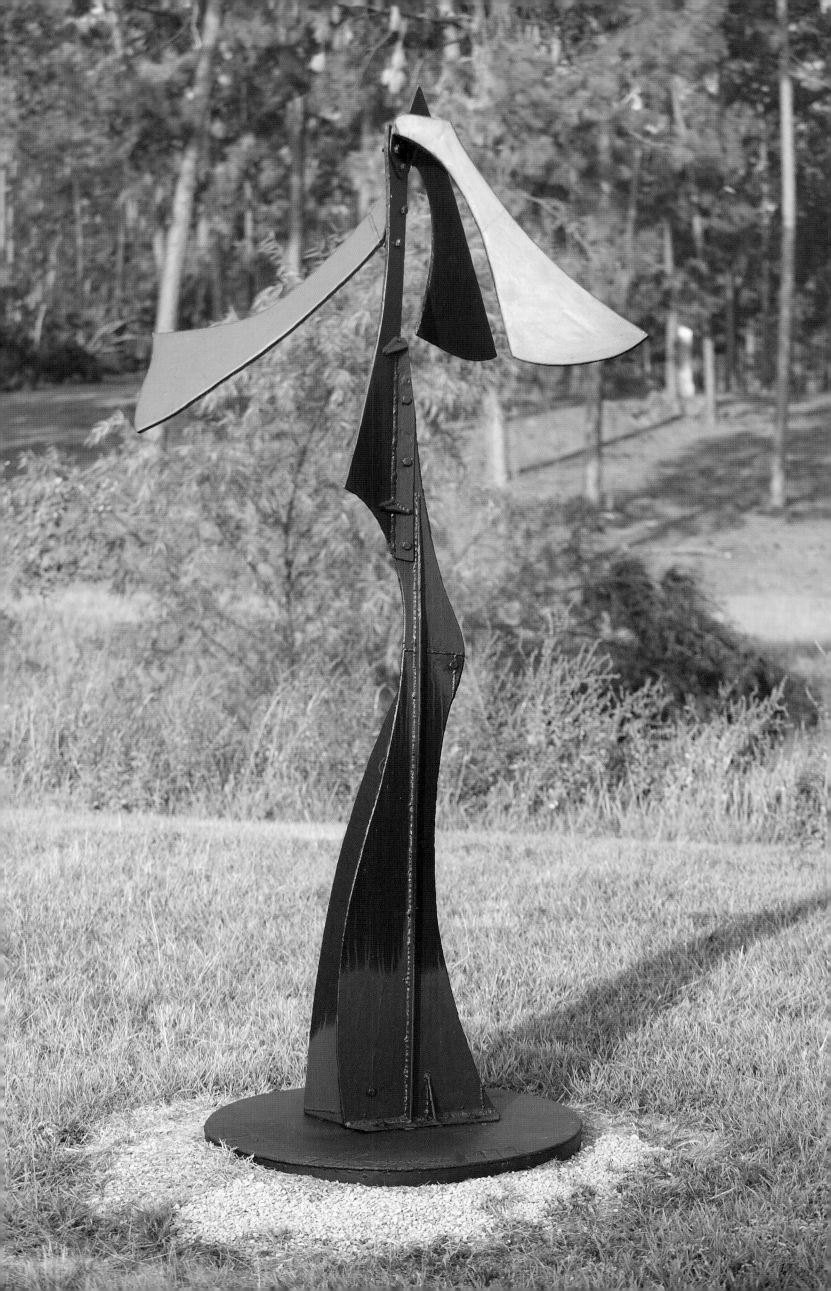

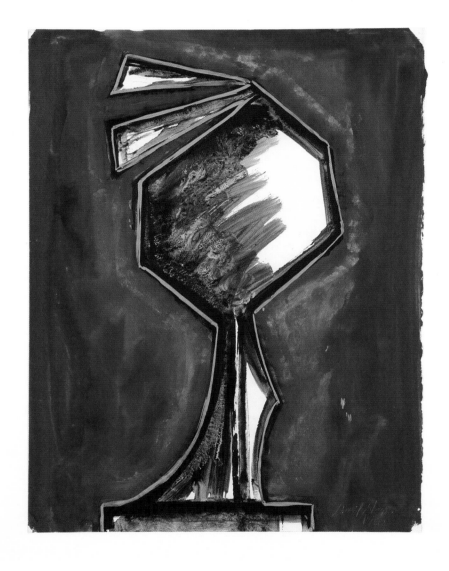

Study For Vertical Motif #13, 1980. Ink and gouache on paper. 26 × 21 inches framed.

Next page: *Vertical Motif #13,* 1978. Welded, painted steel. 96.5 × 36 × 49 inches.

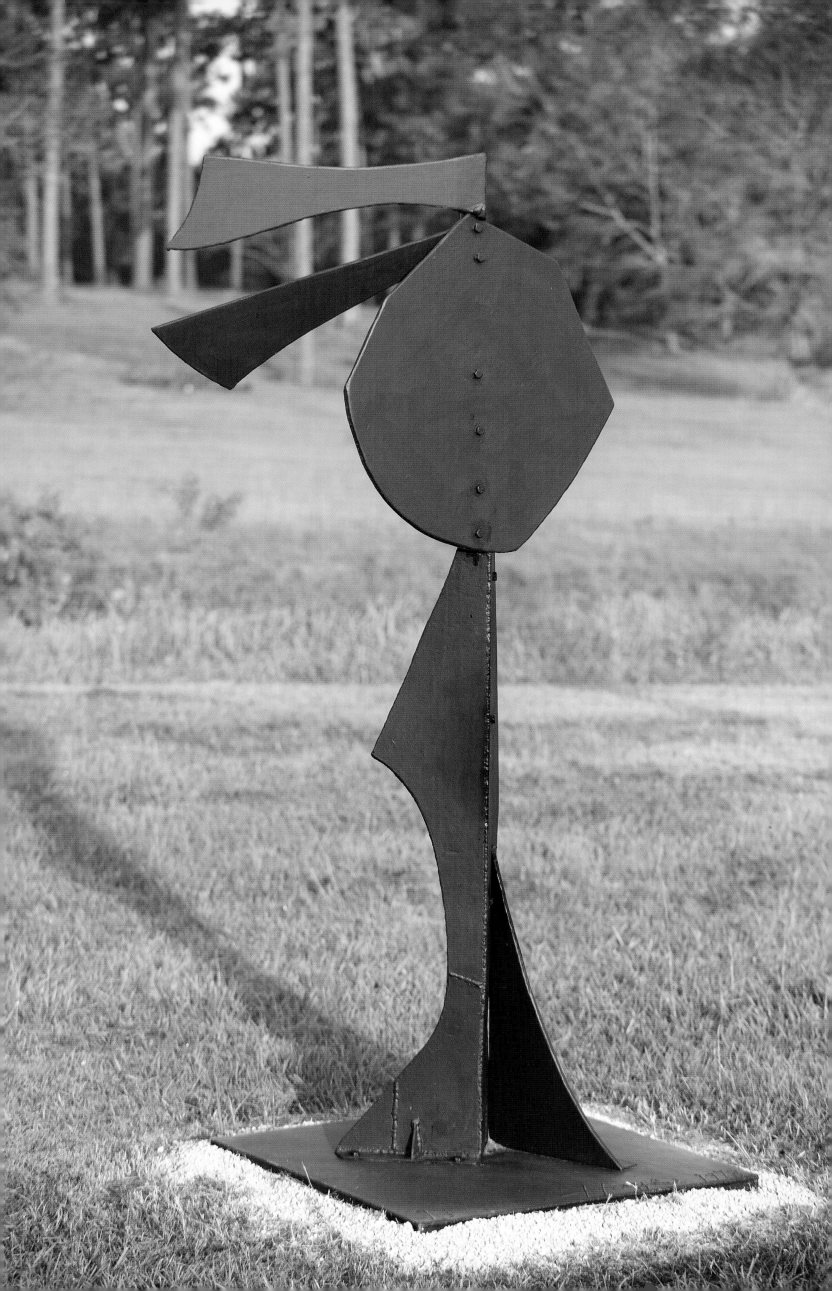

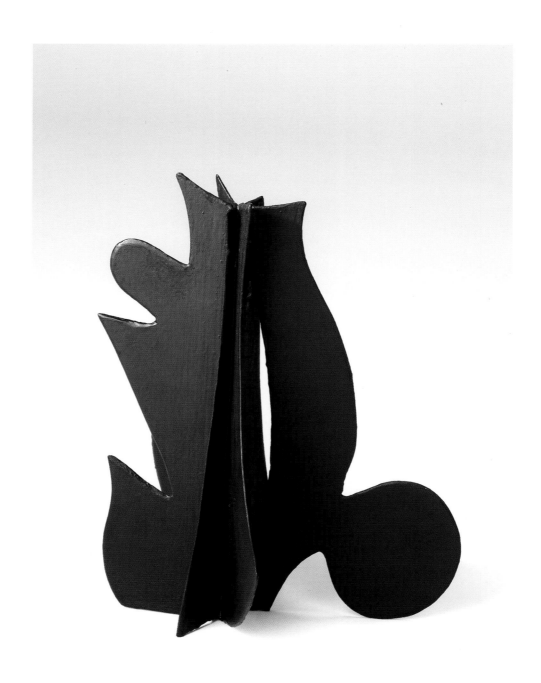

Vertical Motif Maquette, 2004. Welded, painted steel. 11.5 × 9 × 8 inches.

Next page: *Vertical Motif #15,* 1979. Welded, painted steel. 91 × 33.5 × 32 inches.

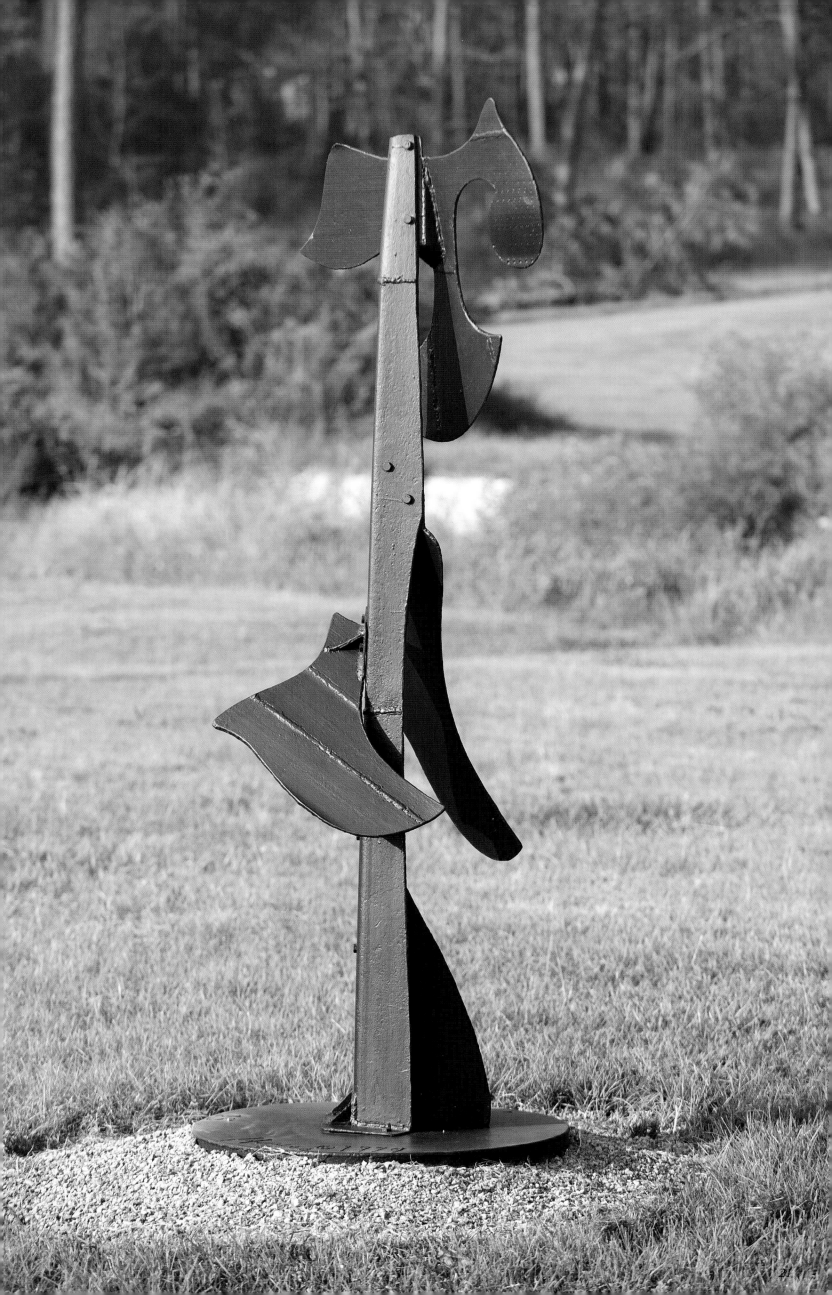

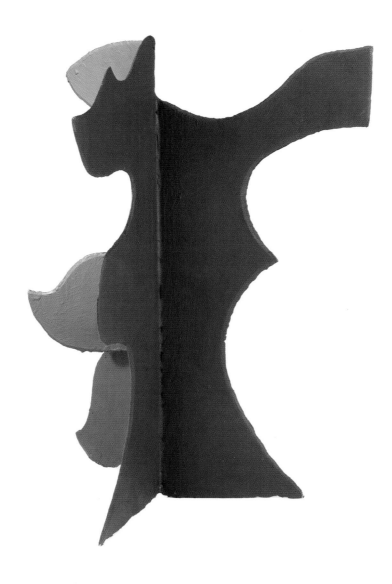

Vertical Motif Maquette, 2005. Welded, painted steel. 20 × 12 × 12 inches.

Next page: *Vertical Motif #19,* 1980. Welded, painted steel. 97 × 48 × 38.5 inches.

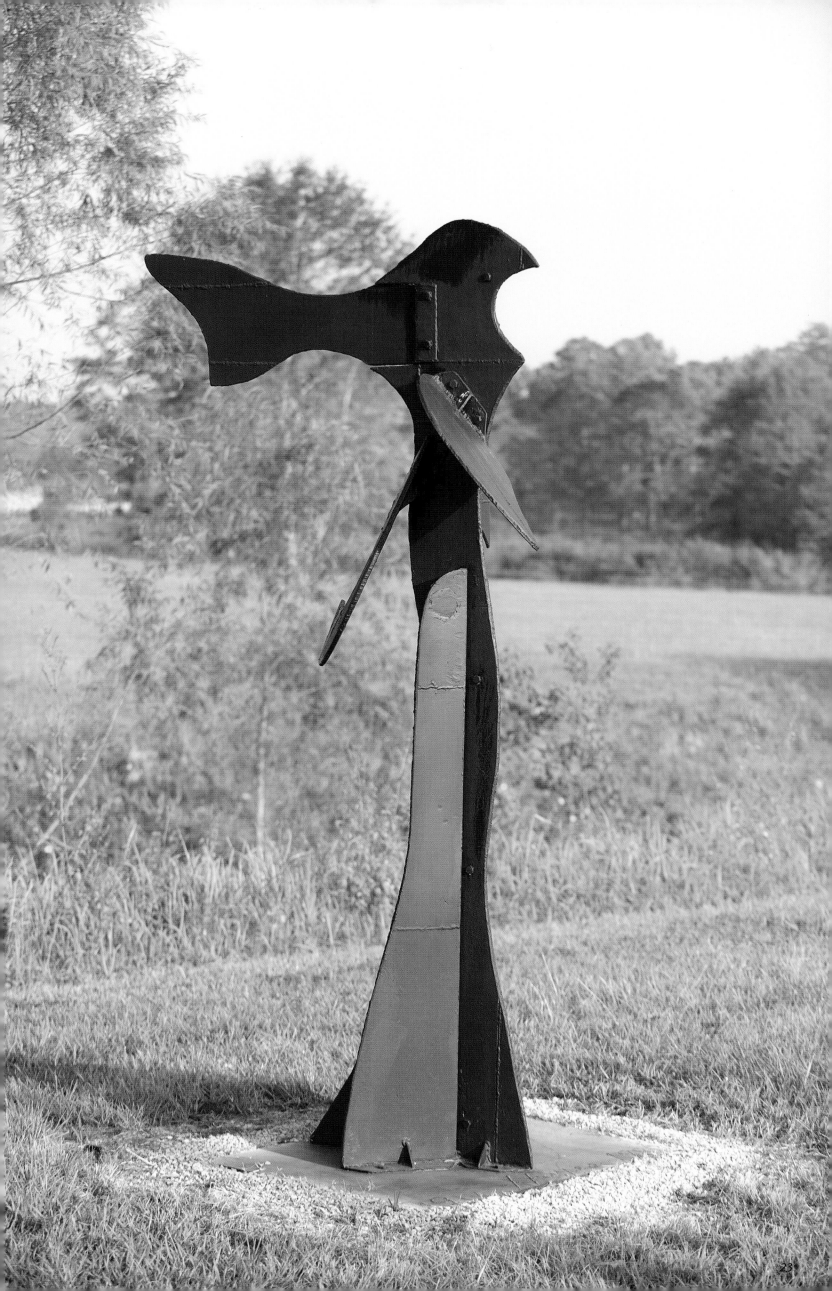

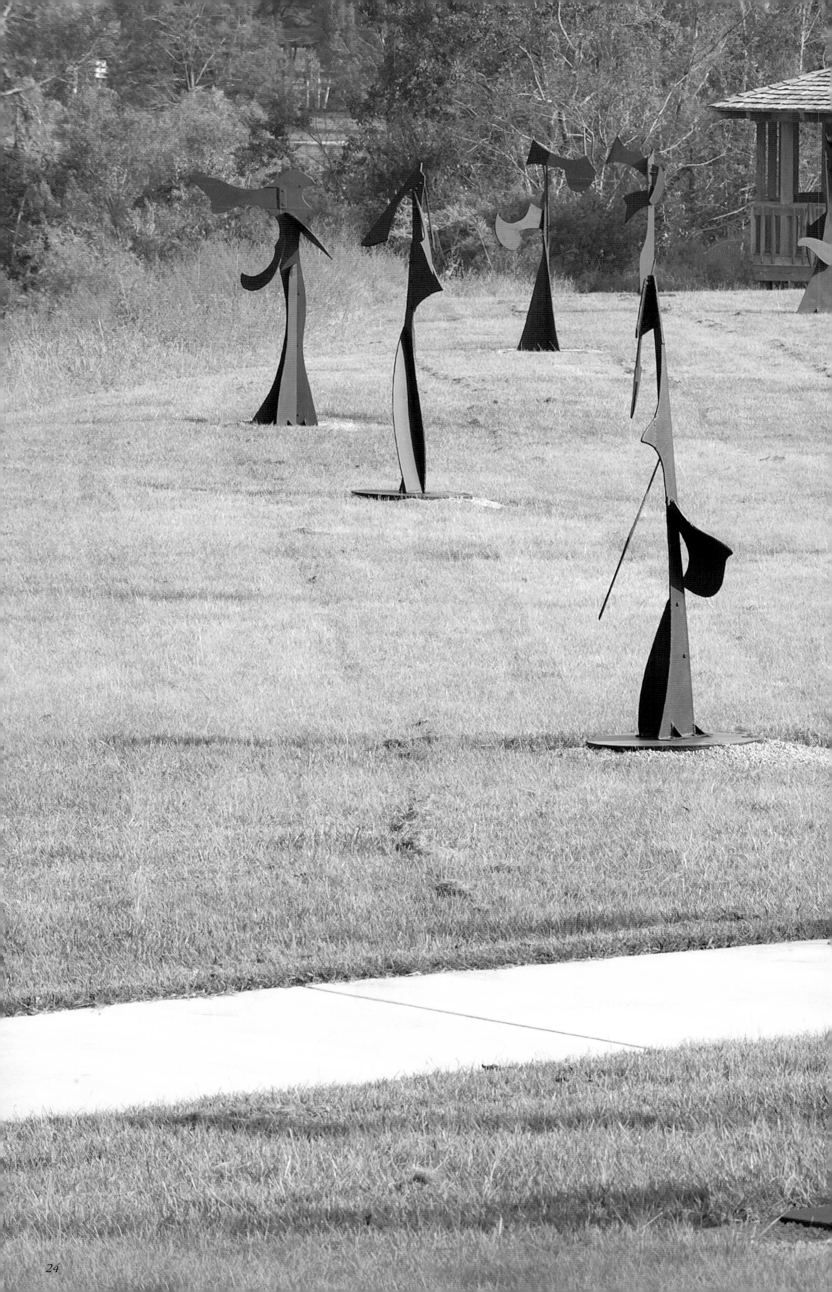

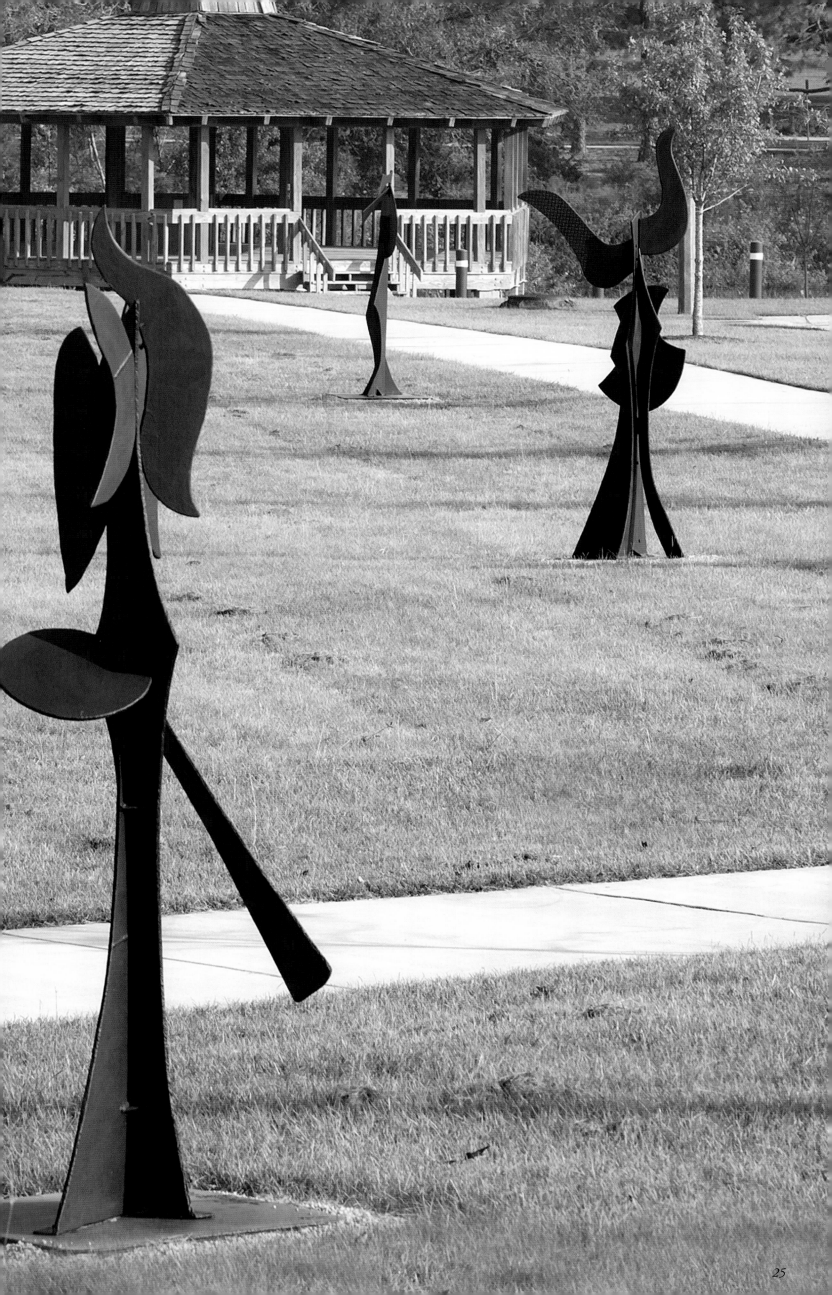

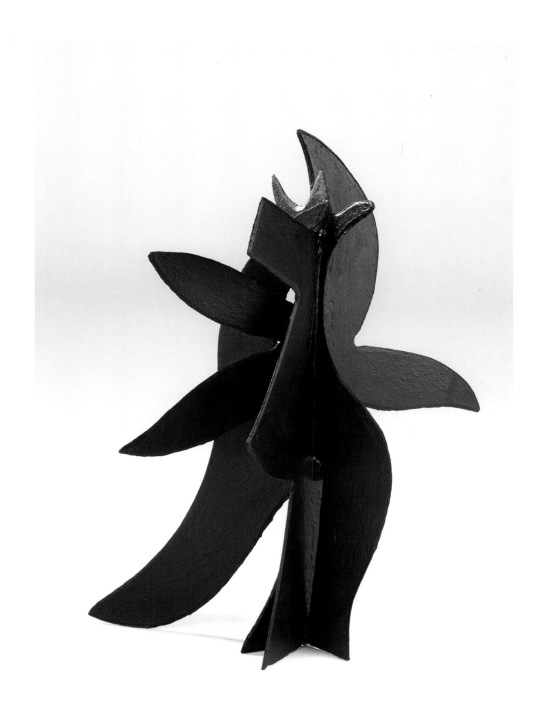

Vertical Motif Maquette, 1992. Welded, painted steel. 17.5 × 13 × 11 inches.

Next page: *Vertical Motif #21,* 1987. Welded, painted steel. 119 × 31 × 46 inches.

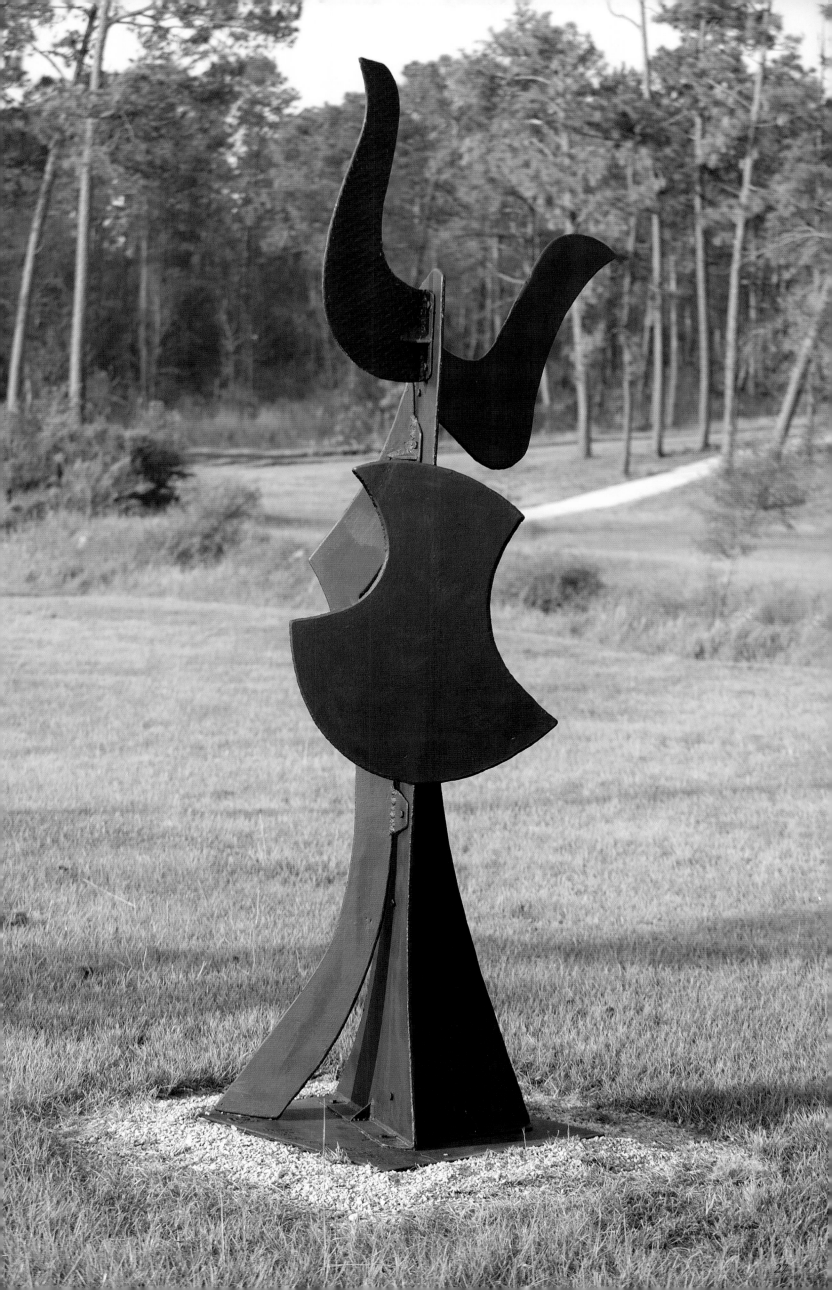

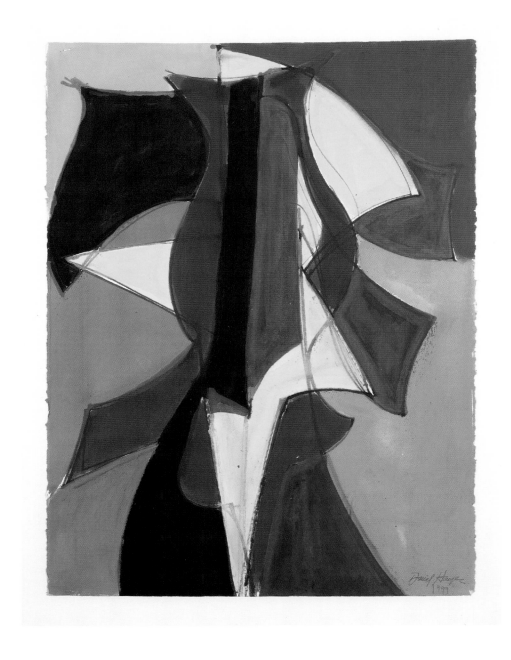

Study For Small Sculpture, 1999. Ink and gouache on paper. 30 × 22 inches.

Next page: *Vertical Motif #30,* 2005. Welded, painted steel. 103 × 42 × 32 inches.

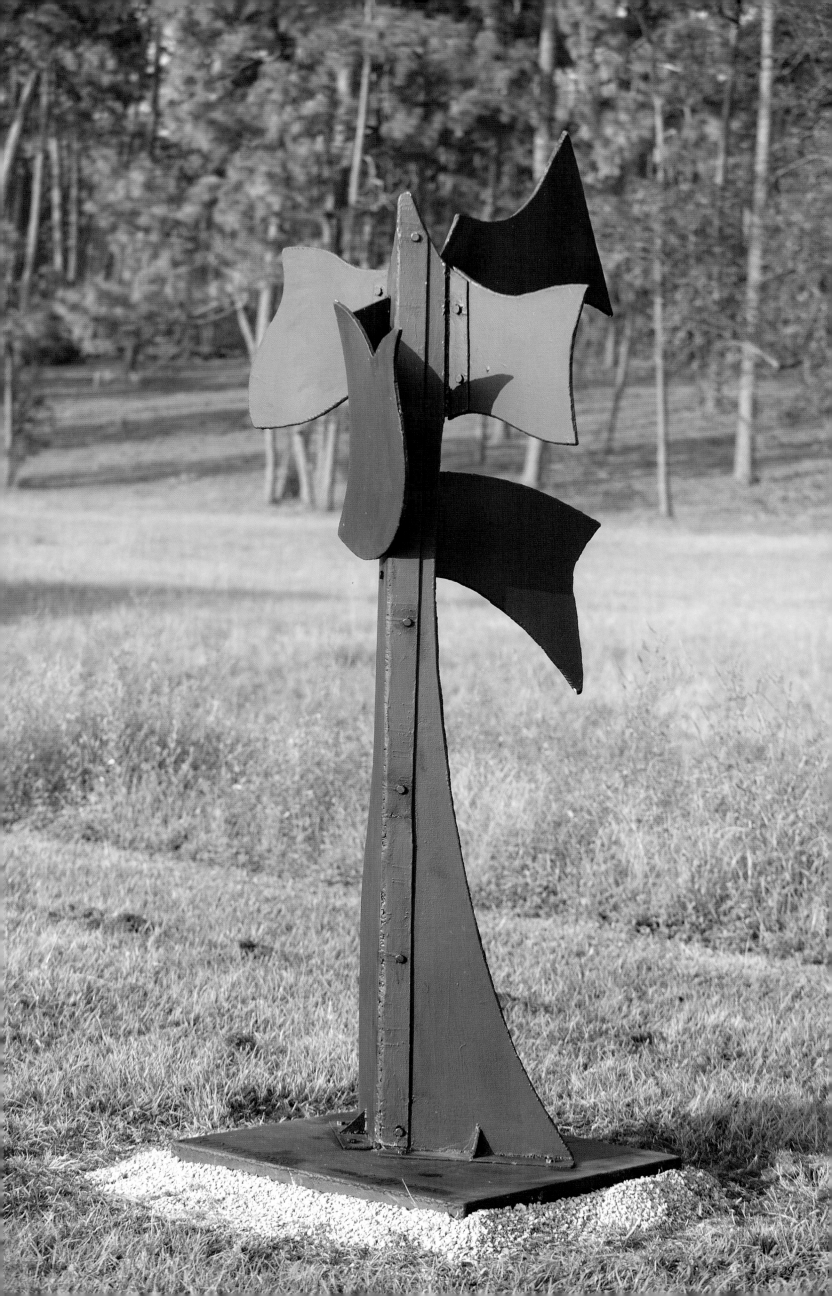

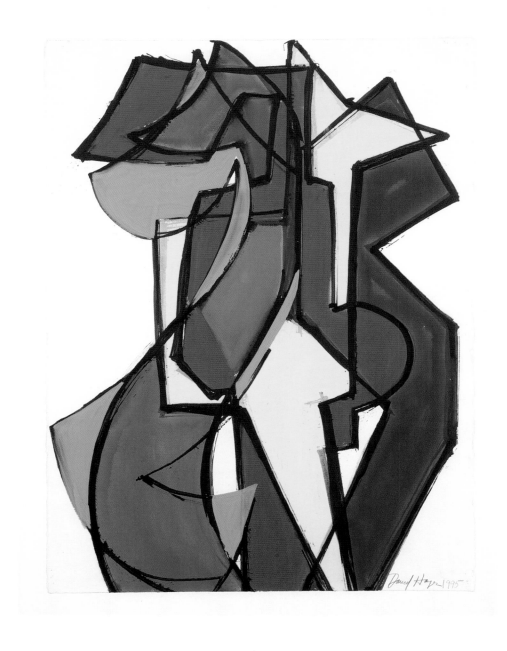

Study for Small Sculpture, 1995. Ink and gouache on paper. 30 × 22 inches.

Next page: *Small Sculpture,* 1995. Welded, painted steel. 28.5 × 21 × 18 inches.

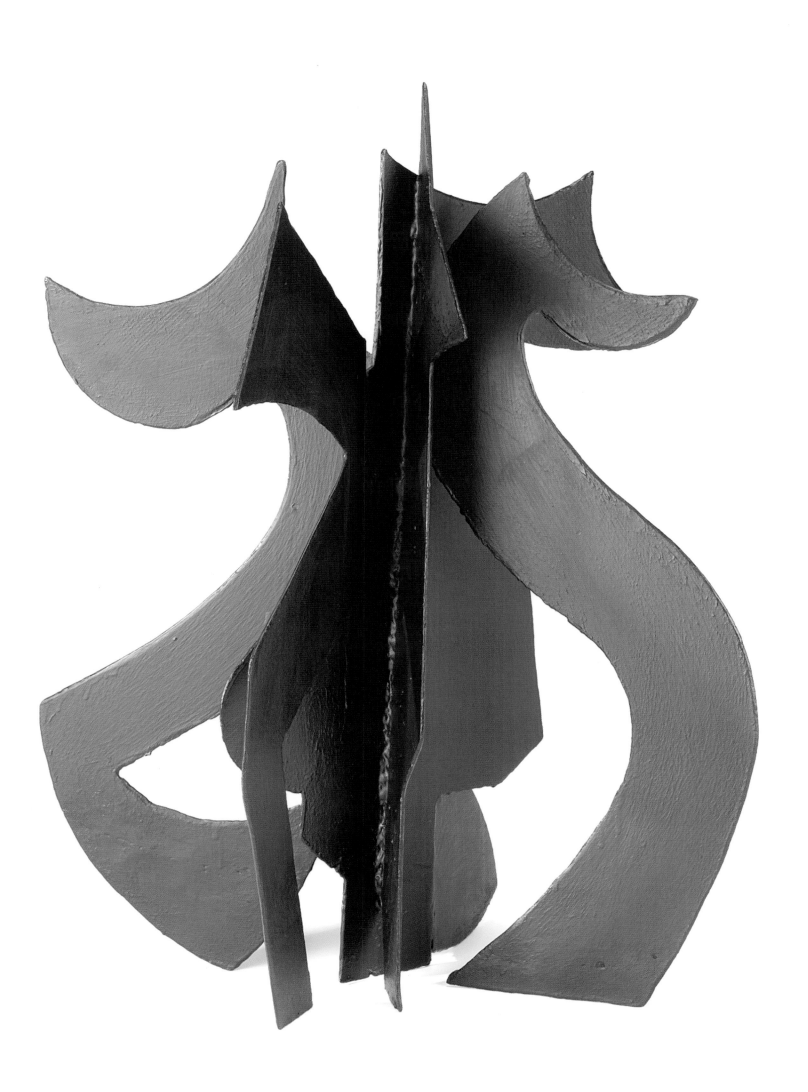

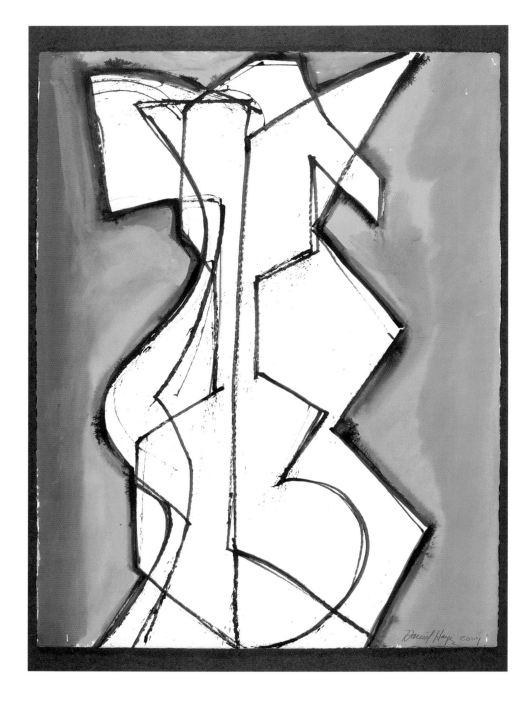

Study For Small Maquette, 2004. Ink and gouache on paper. 30 × 22 inches.

Next page: *Vertical Motif Maquette,* 2005. Welded, painted steel. 20 × 13 × 11 inches.

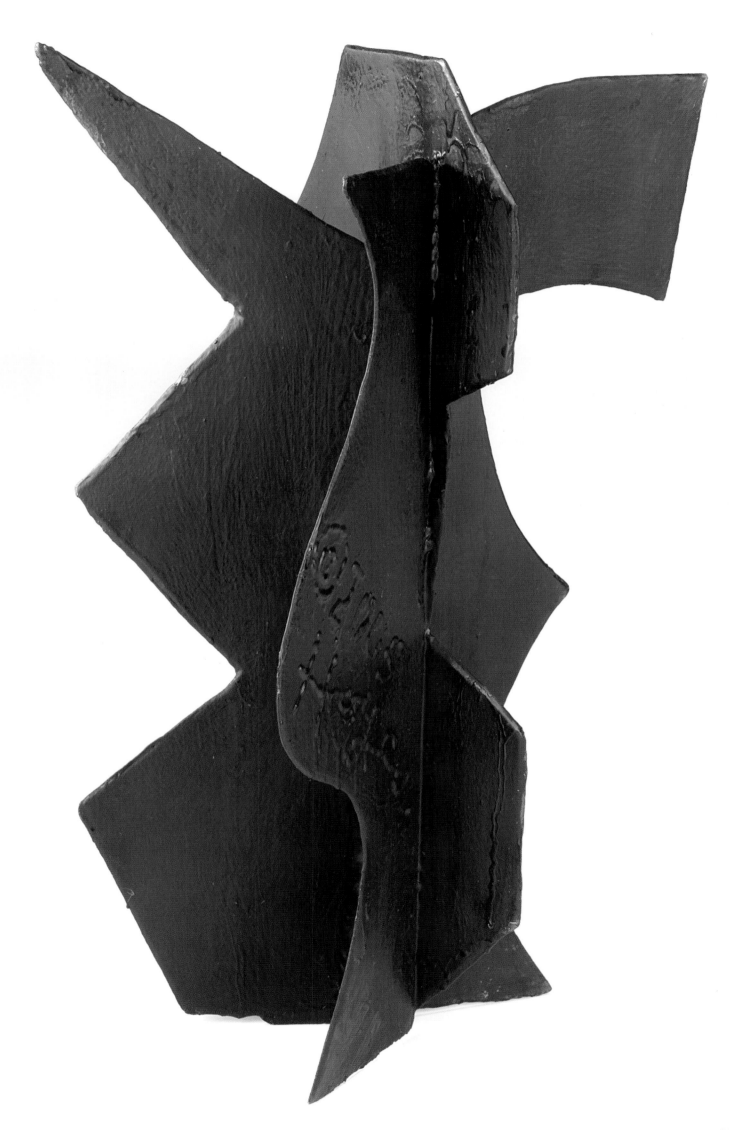

33

Next page: *Vertical Motif Maquette,* 2005. Welded, painted steel. 21.75 × 13 × 7 inches.

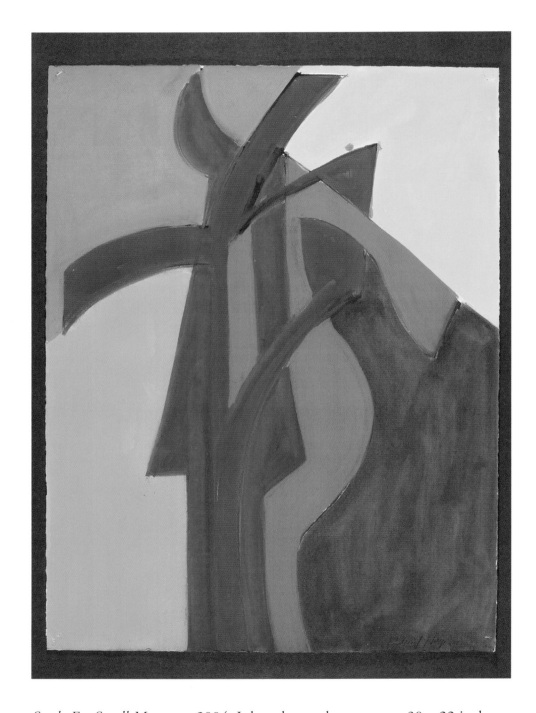

Study For Small Maquette, 2004. Ink and gouache on paper. 30 × 22 inches.

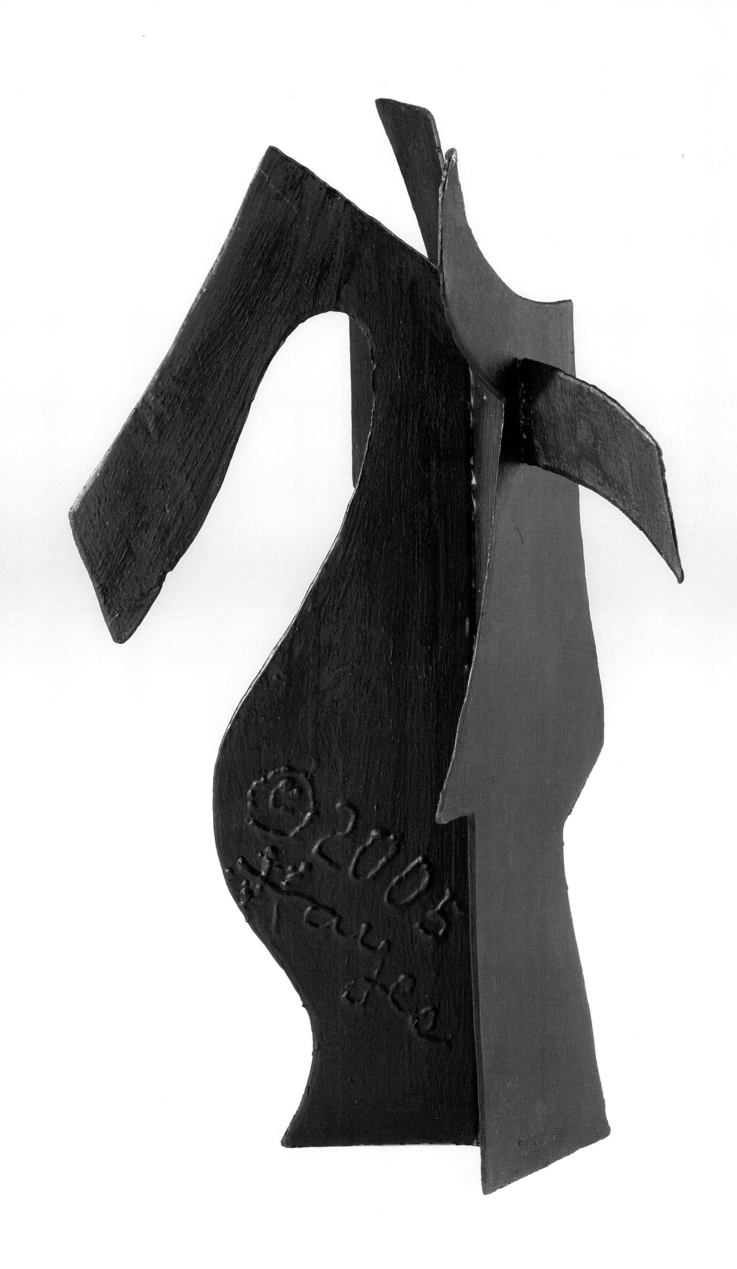

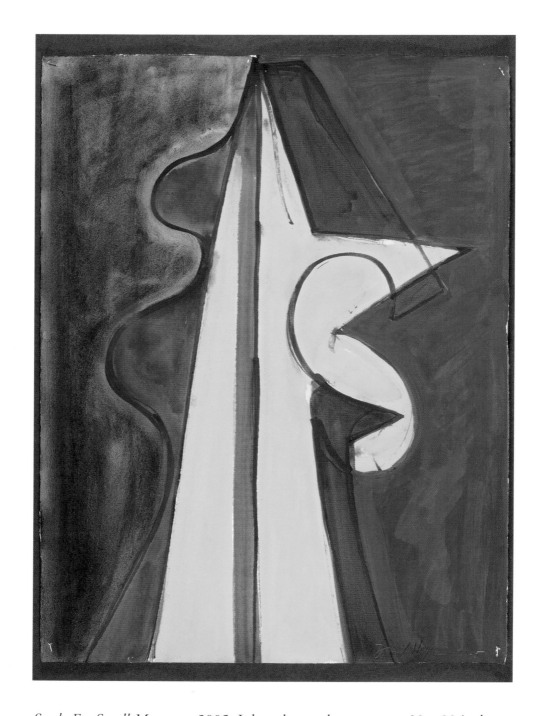

Study For Small Maquette, 2005. Ink and gouache on paper. 30 × 22 inches.

Next page: *Vertical Motif Maquette,* 2005. Welded, painted steel. 21.25 × 12 × 10 inches.

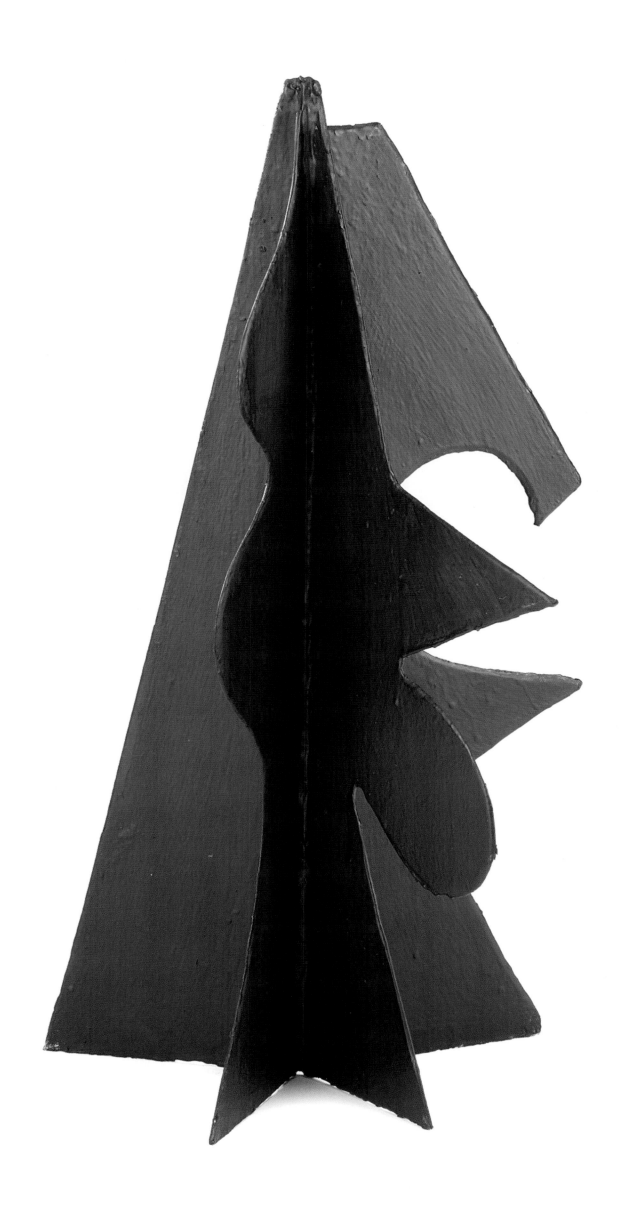

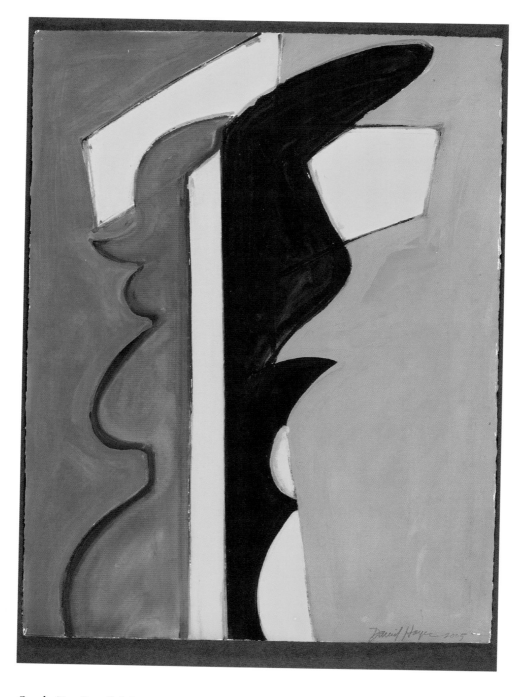

Study For Small Maquette, 2005. Ink and gouache on paper. 30 × 22 inches.

Next page: *Vertical Motif Maquette,* 2005. Welded, painted steel. 21.5 × 12 × 12 inches.

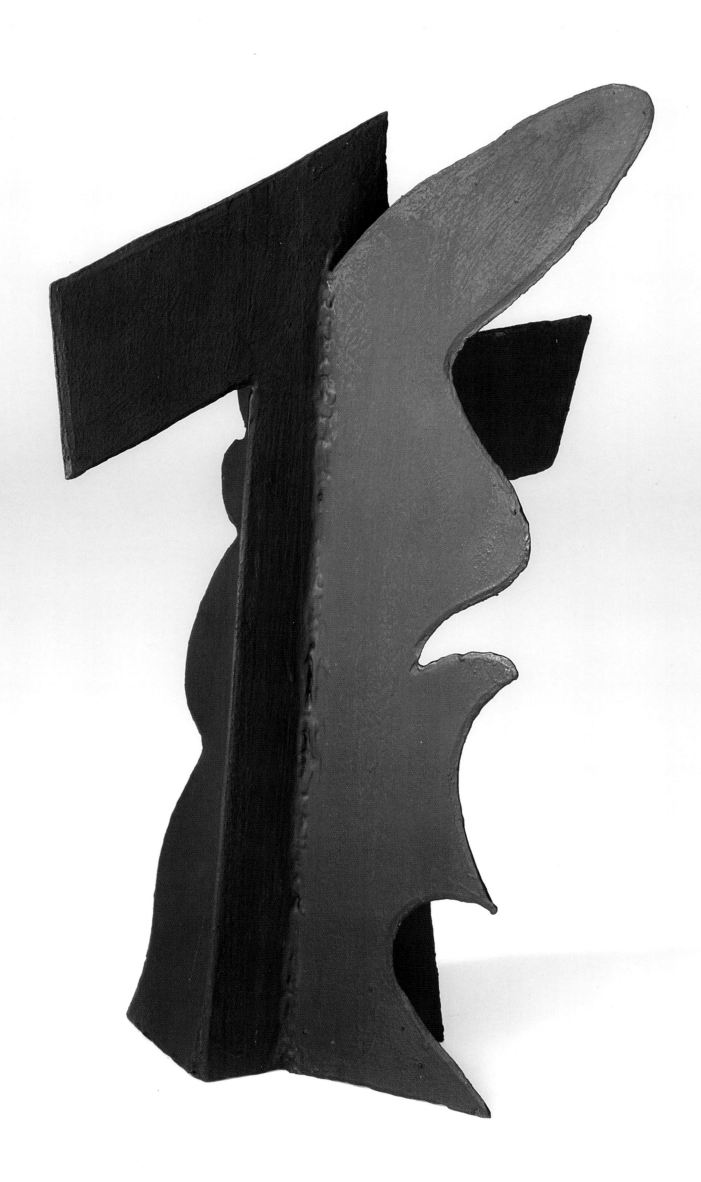

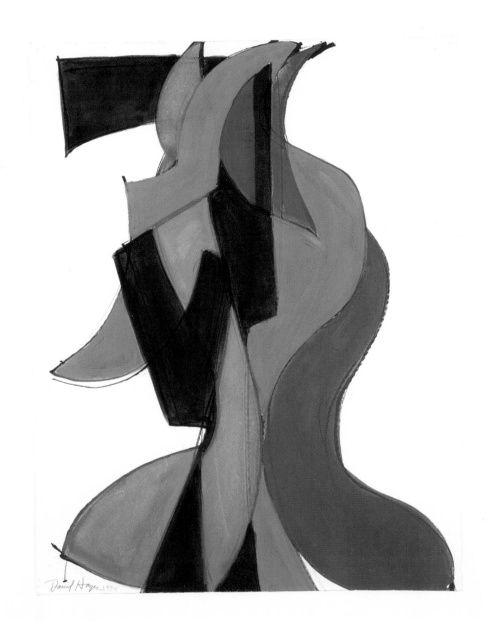

Study For Small Sculpture, 1994. Ink and gouache on paper. 30 × 22 inches.

Next page: *Small Sculpture,* 1994. Welded, painted steel. 32.5 × 23.5 × 13 inches.

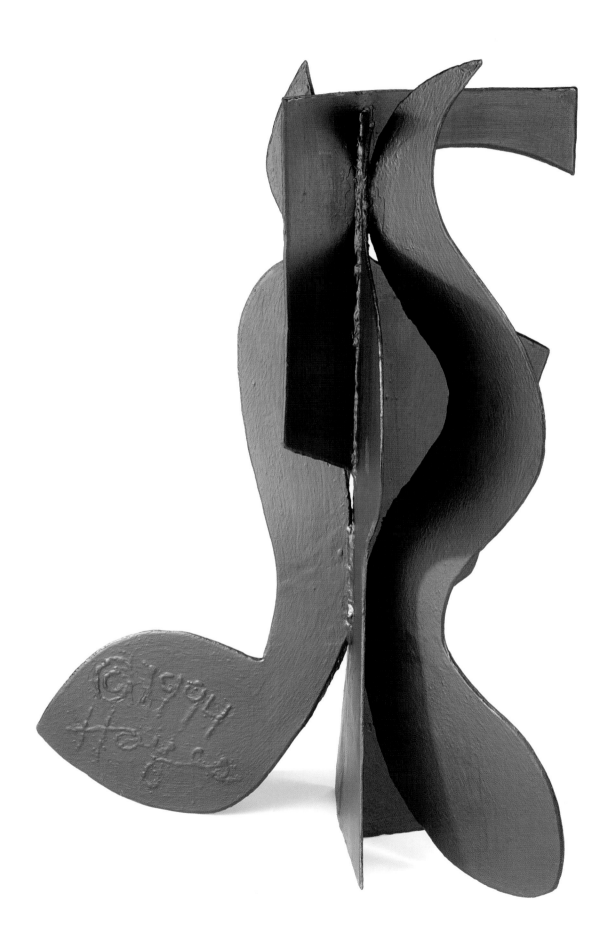

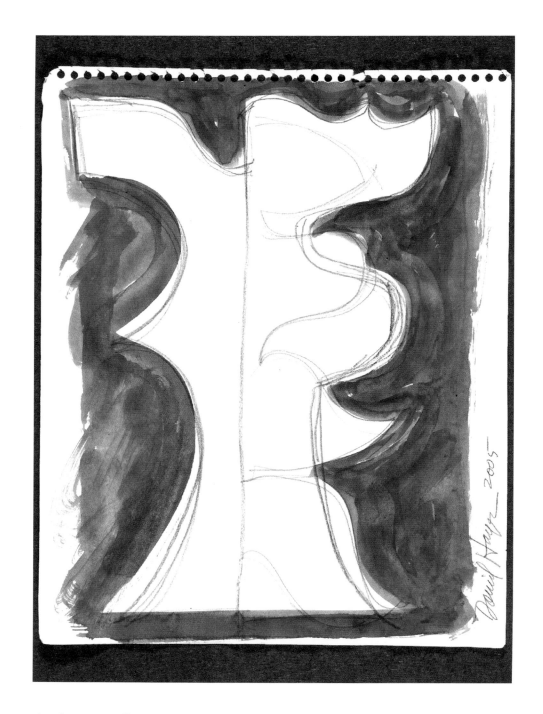

Study For Small Maquette, 2005. Ink and graphite on paper. 14 × 11 inches.

DAVID HAYES

David Hayes was born in Hartford, Connecticut and received an A.B. degree

from the University of Notre Dame in 1953, and a M.F.A. degree from

Indiana University in 1955, where he studied with David Smith. He has

received a post-doctoral Fulbright award and a Guggenheim Fellowship.

He is a recipient of the Logan Prize for Sculpture and an award from the

National Institute of Arts and Letters. He has had over 300 exhibitions and

is included in over 100 institutional collections including that of the

Museum of Modern Art and the Guggenheim Museum in New York.

He resides in Coventry, Connecticut.

David Hayes
Public Collections

Museum of Modern Art, New York

Solomon R. Guggenheim Museum, New York

Addison Gallery of American Art; Andover, Massachusetts

Currier Gallery of Art; Manchester, New Hampshire

Musée des Arts Décoratifs, Paris

Detroit Art Institute; Detroit, Michigan

Museum of Fine Arts; Houston, Texas

University of Michigan; Ann Arbor, Michigan

Arizona State University; Tempe, Arizona

Carnegie Institute; Pittsburgh, Pennsylvania

Wadsworth Atheneum; Hartford, Connecticut

Elmira College; Elmira, New York

Brockton Art Center, Fuller Memorial;
 Brockton, Massachusetts

Ringling Museum of Art; Sarasota, Florida

Fleming Museum, University of Vermont;
 Burlington, Vermont

First National Bank of Chicago; Chicago, Illinois

De Porceleyne Fles; Delft, Holland

University of Connecticut; Storrs, Connecticut

Columbus Gallery of Fine Arts; Columbus, Ohio

University of Notre Dame; Notre Dame, Indiana

Michael Schiavone and Sons; New Haven, Connecticut

Indiana University; Bloomington, Indiana

National Museum of American Art; Washington, D. C.

Struktuur 68NV; The Hague, Holland

Boston Public Library; Boston, Massachusetts

Dartmouth College; Hanover, New Hampshire

Everson Museum of Art; Syracuse, New York

Dade County Art Collection; Miami, Florida

Williams College Museum of Art;
 Williamstown, Massachusetts

George Washington University; Washington, D. C.

New Britain Museum of American Art;
 New Britain, Connecticut

Brooklyn Museum; Brooklyn, New York

Price, Waterhouse, Inc.; Hartford, Connecticut

Russell, Gibson, Von Dolen, Inc.; Hartford, Connecticut

Thiokol Corporation; Newtown, Pennsylvania

University Art Museum, State University of New York;
 Albany, New York

Lynch Motors; Manchester, Connecticut

Housatonic Museum of Art; Bridgeport, Connecticut

Boca Raton Museum; Boca Raton, Florida

Museum of Fine Arts; Springfield, Massachusetts

Wichita State University; Wichita, Kansas

Gund Hall, Harvard University; Cambridge,
 Massachusetts

The Norton Company; Worcester, Massachusetts

National Trust for Historic Preservation, Nelson
 Rockefeller Collection; Tarrytown, New York

Harry Guggenheim Collection, Nassau County Museum;
 Sands Point, New York

Fitchburg Art Museum; Fitchburg, Massachusetts

Ohio Weslyan University; Delaware, Ohio

Hunter Museum of Art; Chattanooga, Tennessee

Albertus Magnus College; New Haven, Connecticut

Wilbraham and Monson Academy;
 Wilbraham, Massachusetts

Westmoreland County Museum of Art;
 Greensburg, Pennsylvania

Wondriska & Russo Associates; Farmington, Connecticut

The Woodlands, Texas

Philbrook Art Center; Tulsa, Oklahoma

Pfizer Inc.; New York

Pepperidge Farms, Inc.; New Haven, Connecticut

Olin Corporation; Cheshire, Connecticut

Manchester Community College; Manchester,
 Connecticut

Hartford Public Library; Hartford, Connecticut

BKM, Inc.; East Hartford, Connecticut

Western Michigan University; Kalamazoo, Michigan

Hollister Corporation; Libertyville, Illinois

Hartford Art School; West Hartford, Connecticut

University of Hartford; West Hartford, Connecticut

Michener Museum; Doylestown, Pennsylvania

Gerwun Jewish Heritage Foundation, New York

University of Connecticut Health Center;
 Farmington, Connecticut

Westminster School; Simsbury, Connecticut

Hartwood Acres; Pittsburgh, Pennsylvania

University of New Haven, West Haven, Connecticut

Gulf Coast Art Center, Belleair, Florida

Picker Art Gallery, Colgate University;
 Hamilton, New York

Naples Art Association at The von Liebig Art Center;
 Naples, Florida

Emerson Gallery, Hamilton College; Clinton, New York

The City of Fort Pierce, Florida

David Hayes
Solo Exhibitions – 1955 to 2005

2005 Mobile Museum of Art; Mobile, Alabama – *Vertical Motifs*
Hartwick College; Oneonta, New York – *12 Sculptures on Oyaron Hill*
Krasl Art Center; Saint Joseph, Michigan – *Small Sculptures and Drawings*
Yaeger Art Museum; Oneonta, New York – *Small Sculptures and Drawings*
Erie Museum; Erie, Pennsylvania – *Downtown Sculptures*

2004 FIU Biscayne Bay Campus; Miami, Florida – *David Hayes Sculpture at Florida International University*
James A. Michener Art Museum; Doylestown, Pennsylvania – *David Hayes Outdoor Sculpture Installation*
Fort Pierce, St. Lucie County and Core Developers, Florida – *Exhibition Without Walls*

2003 Burt Reynolds Museum; Jupiter, Florida – *Inaugural exhibition*
Orlando, Florida – *5 Screen Sculptures at the University of Central Florida*
Sculpture Garden & Studio at Gidion's; Kent, Connecticut – *David Hayes Sculpture*

2002 Lyric Theater Sculpture Garden; Stuart, Florida – *Outdoor Sculpture*
Bradley International Airport; Windsor Locks, Connecticut – *Small Sculptures*

2001 Geary Design; Naples, Florida – *David Hayes Sculpture, Graham Nickson Paintings*
Lyric Theater Sculpture Garden; Stuart, Florida – *Outdoor Sculpture*

2000 Sasaki, Inc.; Watertown, Massachusetts; *Sculpture, Maquettes, Wall Reliefs*
Fordham University Downtown; New York, New York – *Wall Sculptures and Drawings*
Denise Bibro Fine Arts Inc.; New York, New York – *David Hayes Steel Sculpture*

1999 *Screen Sculpture Commission,* Nicotra Group; Staten Island, New York
Colgate University; Hamilton, New York – *Sculpture, Maquette Reliefs*

1998 Mercy Gallery, Loomis Chaffee School; Windsor, Connecticut – *Drawings, Macquettes, Reliefs, and Screen Sculptures*
City of Stamford, Connecticut and Stamford Town Center – *Stamford Sculpture Walk: 59 Sculptures in Stamford, Connecticut*
Tremaine Gallery, Hotchkiss School; Lakeville, Connecticut – *Drawings, Macquettes, Reliefs and Polychrome Sculptures*
Boca Raton Museum of Art; Boca Raton, Florida – *Vertical Motifs, Drawings, Macquettes and Large Vertical Motifs*
The Appleton Museum; Ocala, Florida – *Large Vertical Motifs*
Stamford Center for the Arts, Rich Forum; Stamford, Connecticut – *David Hayes: Paintings, Acrylic Landscapes and Studies*

1997 100 Pearl Gallery; Hartford, Connecticut – *Sculpture, Drawings and Macquettes*
The Gallery, University of New Haven; West Haven, Connecticut – *Sculpture and Paintings*
Southern Vermont Art Center; Manchester, Vermont – *Screen Sculptures*
Gulf Coast Museum of Art; Largo, Florida – *Screen Sculptures*
Orlando City Hall; Orlando, Florida – *Screen Sculptures*
Hines Building; Boston, Massachusetts – *Five Screen Sculptures*
Hayes Modern Gallery; Naples, Florida – *Sculptures, Drawings and Macquettes*

1996 Prudential Center; Boston, Massachusetts – *Screen Sculptures*
Gulf Coast Art Center; Belair, Florida – *Screen Sculptures*
The Pingry School; Martinsville, New Jersey – *Sculpture, Drawings and Macquettes*

1994 Anderson Gallery, Buffalo, New York – *A Survey of Screen Sculptures – Sculptures, Macquettes and Drawings.*

1993 Elaine Benson Gallery, Bridgehampton, New York – *Screen Sculptures*

1992 Gallerie Françoise; Baltimore, Maryland – *David Hayes—Outdoor Sculpture*

1991 Neville-Sargent Gallery; Chicago, Illinois – *Sculpture, Macquettes, Drawings and Installation Photographs*

1990 Indiana University Art Museum; Bloomington, Indiana – *Sculpture, Macquettes and Gouaches*

1989 Snite Museum of Art; University of Notre Dame, Notre Dame, Indiana – *Sculpture, Macquettes and Gouaches. Exhibition travels to Indiana University Art Museum*

1988 Station Plaza; Stamford, Connecticut – *Outdoor Sculpture*

1987 Albertus Magnus College; New Haven, Connecticut – *Outdoor Sculpture and Wall Reliefs*

1986 Shippee Gallery; New York, New York – *Vertical Motif Series*

1985 Visual Images Gallery; Wellfleet, Massachusetts – *Sculpture, Gouaches and Small Vertical Motifs*

1984 Visual Images Gallery; Wellfleet, Massachusetts – *Sculpture, Gouaches, and Painted Reliefs*
Shippee Gallery; New York, New York – *Recent Sculpture and Works on Paper*

1983 Weslyan Potters; Middletown, Connecticut – *Sculpture, Drawings, and Ceramics*
Visual Images Gallery; Wellfleet, Massachusetts – *Sculpture, Drawings, Ceramics and Small Bronzes*
Rensselaer County Council for the Arts; Troy, New York – *Sculpture, Drawings, and Reliefs*

1982 Sunne Savage Gallery; Boston, Massachusetts – *Sculpture and Drawings*
Elaine Benson Gallery; Bridgehampton, New York – *Sculpture and Models*
Visual Images Gallery; Wellfleet, Massachusetts – *Sculpture, Drawings, and Ceramics*

1981 Bard College; Annandale, New York – *Outdoor Sculpture*
Old State House; Hartford, Connecticut – *Sculpture on Old State House Lawn*
June 1 Gallery; Bethlehem, Connecticut – *Sculpture and Drawings*
Visual Images Gallery; Wellfleet, Massachusetts – *Sculpture, Gouaches, Ceramics*
University of Maryland, Baltimore Campus; Catonsville, Maryland – *Cross Section, Drawings, Ceramics, Tapestries, Sculpture*

1980 Bethel Gallery and Bethel Library grounds; Bethel, Connecticut – *Sculpture Inside/Outside*
Art Museum and City of Fitchburg; Fitchburg, Massachusetts – *Sculpture, Drawings, and Ceramics*
Saratoga Performing Arts Center; Saratoga Springs, New York – *Outdoor Sculpture*
Skidmore College; Saratoga Springs, New York – *Sculpture and Drawings*

1979 Amherst College; Amherst, Massachusetts – *Sculpture*
Nassau County Museum; Sands Point, New York – *Outdoor Sculpture*
The Gallery, G. Fox and Company; Hartford, Connecticut
White Mountains Center for the Arts; Jefferson, New Hampshire
Plymouth State College; Plymouth, New Hampshire
University Library, University of Connecticut; Storrs, Connecticut – *Sculpture in the Library*

1978 Museum of Fine Arts and City of Springfield; Springfield, Massachusetts – *On Loan to Springfield: Sculpture, Ceramics, Drawings*
Choate-Rosemary Hall; Wallingford, Connecticut – *Outdoor Sculpture*
State University of New York; Albany, New York – *Sculpture and Drawings*
Manchester Community College; Manchester, Connecticut – *Outdoor Sculpture*
Dartmouth College; Hanover, New Hampshire – *Sculpture on Tuck Mall*

1977 Franz Bader Gallery; Washington, D. C. – *Sculpture and Ceramics*
George Washington University; Washington, D. C. – *Outdoor Sculpture*
Georgetown University Hospital; Washington, D. C. – *Five Sculptures*
DeCordova Museum; Lincoln, Massachusetts – *Outdoor Sculpture*

1976 Danbury, Connecticut – *Sculpture in the City*

1975 Everson Museum of Art; Syracuse, New York – *Sculpture*
Brockton Art Center, Fuller Memorial; Brockton, Massachusetts

1974 Copley Square and Dartmouth Street Mall; Boston, Massachusetts
Martha Jackson Gallery; New York – *Ceramics*
Columbus Gallery of Fine Art; Columbus, Ohio
Sunne Savage Gallery; Boston, Massachusetts

1973 Munson Gallery; New Haven, Connecticut
Sunne Savage Gallery; Boston, Massachusetts
Albany Institute of History and Art; Albany, New York
Gallery Five East; East Hartford, Connecticut

1971 Harvard University, Hunt Hall; Cambridge, Massachusetts
New Britain Museum of American Art; New Britain, Connecticut
Agra Gallery; Washington, D. C.

1970 University of Connecticut; Storrs, Connecticut
Manchester Community College; Manchester, Connecticut
St. Joseph's College; West Hartford, Connecticut

1969 Bard College; Annandale-on-Hudson, New York
Willard Gallery; New York
Arizona State University; Tempe, Arizona

1968 Galerie De Haas; Rotterdam, Holland – *Ceramics*

1966 Lyman Allen Museum; New London, Connecticut
Houston Festival of Arts; Houston, Texas
Willard Gallery; New York
David Anderson Gallery; Paris

1963 Root Art Center, Hamilton College; Clinton, New York – *Sculpture and Drawings*

1962 University of Notre Dame and Indiana University; Notre Dame and Bloomington, Indiana – *Retrospective Exhibition of Sculpture and Drawing*

1961 Willard Gallery, New York

1960 Sharon Creative Art Foundation; Sharon, Connecticut – *Two-man show with Cleve Gray*

1959 Lyman Allen Museum; New London, Connecticut
Museum of Modern Art; New York – *New Talent Series*

1958 Wesleyan University; Middletown, Connecticut

1955 Indiana University; Bloomington, Indiana – *Thesis Exhibition*

LIST OF WORKS

Vertical Motifs

Vertical Motif #4, 1976. Welded, painted steel. 100 × 42 × 36 inches.

Vertical Motif #8, 1977. Welded, painted steel. 113 × 18 × 42 inches.

Vertical Motif #10, 1977. Welded, painted steel. 103 × 50 × 36 inches.

Vertical Motif #12, 1978. Welded, painted steel. 101 × 48 × 37 inches.

Vertical Motif #13, 1978. Welded, painted steel. 96.5 × 36 × 49 inches.

Vertical Motif #15, 1979. Welded, painted steel. 91 × 33.5 × 32 inches.

Vertical Motif #19, 1980. Welded, painted steel. 97 × 48 × 38.5 inches.

Vertical Motif #21, 1987. Welded, painted steel. 119 × 31 × 46 inches.

Vertical Motif #30, 2005. Welded, painted steel. 103 × 42 × 32 inches.

Small Sculptures

Small Sculpture, 1995. Welded, painted steel. 29.5 × 21 × 21 inches.

Vertical Motif Maquette, 2004. Welded, painted steel. 11.5 × 9 × 8 inches.

Vertical Motif Maquette, 2005. Welded, painted steel. 20 × 12 × 12 inches.

Vertical Motif Maquette, 1992. Welded, painted steel. 17.5 × 13 × 11 inches.

Small Sculpture, 1995. Welded, painted steel. 28.5 × 21 × 18 inches.

Vertical Motif Maquette, 2005. Welded, painted steel. 20 × 13 × 11 inches.

Vertical Motif Maquette, 2005. Welded, painted steel. 21.75 × 13 × 7 inches.

Vertical Motif Maquette, 2005. Welded, painted steel. 21.25 × 12 × 10 inches.

Vertical Motif Maquette, 2005. Welded, painted steel. 21.5 × 12 × 12 inches.

Small Sculpture, 1994. Welded, painted steel. 32.5 × 23.5 × 13 inches.

Studies for Sculpture

Study for Vertical Motif, 1976. Ink and gouache on paper. 31 × 23.5 inches framed.

Study For Small Maquette, 2005. Ink and gouache on paper. 30 × 22 inches.

Study for Vertical Motif #12, 1977. Ink and gouache on paper. 27 × 18.25 inches framed.

Study For Vertical Motif #13, 1980. Ink and gouache on paper. 26 × 21 inches framed.

Study For Small Sculpture, 1999. Ink and gouache on paper. 30 × 22 inches.

Study for Small Sculpture, 1995. Ink and gouache on paper. 30 × 22 inches.

Study For Small Maquette, 2004. Ink and gouache on paper. 30 × 22 inches.

Study For Small Maquette, 2004. Ink and gouache on paper. 30 × 22 inches.

Study For Small Maquette, 2005. Ink and gouache on paper. 30 × 22 inches.

Study For Small Maquette, 2005. Ink and gouache on paper. 30 × 22 inches.

Study For Small Sculpture, 1994. Ink and gouache on paper. 30 × 22 inches.

Study For Small Maquette, 2005. Ink and graphite on paper. 14 × 11 inches.

THE MOBILE MUSEUM OF ART

The beautiful architecture of the new Mobile Museum of Art, designed by TAG (The Architects Group), provides an exquisite setting for significant exhibitions and the museum's permanent collection of more than 6,000 works of art. The new museum, completed in the spring of 2002, is now the largest art museum along the Gulf Coast from New Orleans to Tampa.

The collection is strong in American art of the 1930s-40s, work by southern artists, art of the French Barbizon School, contemporary American crafts and late 19th century American art. The museum has holdings in Asian, African and European works as well.

The Mobile Museum of Art is located at 4850 Museum Drive in Langan Park. For hours and fees please see the museum's website: www.mobilemuseumofart.com

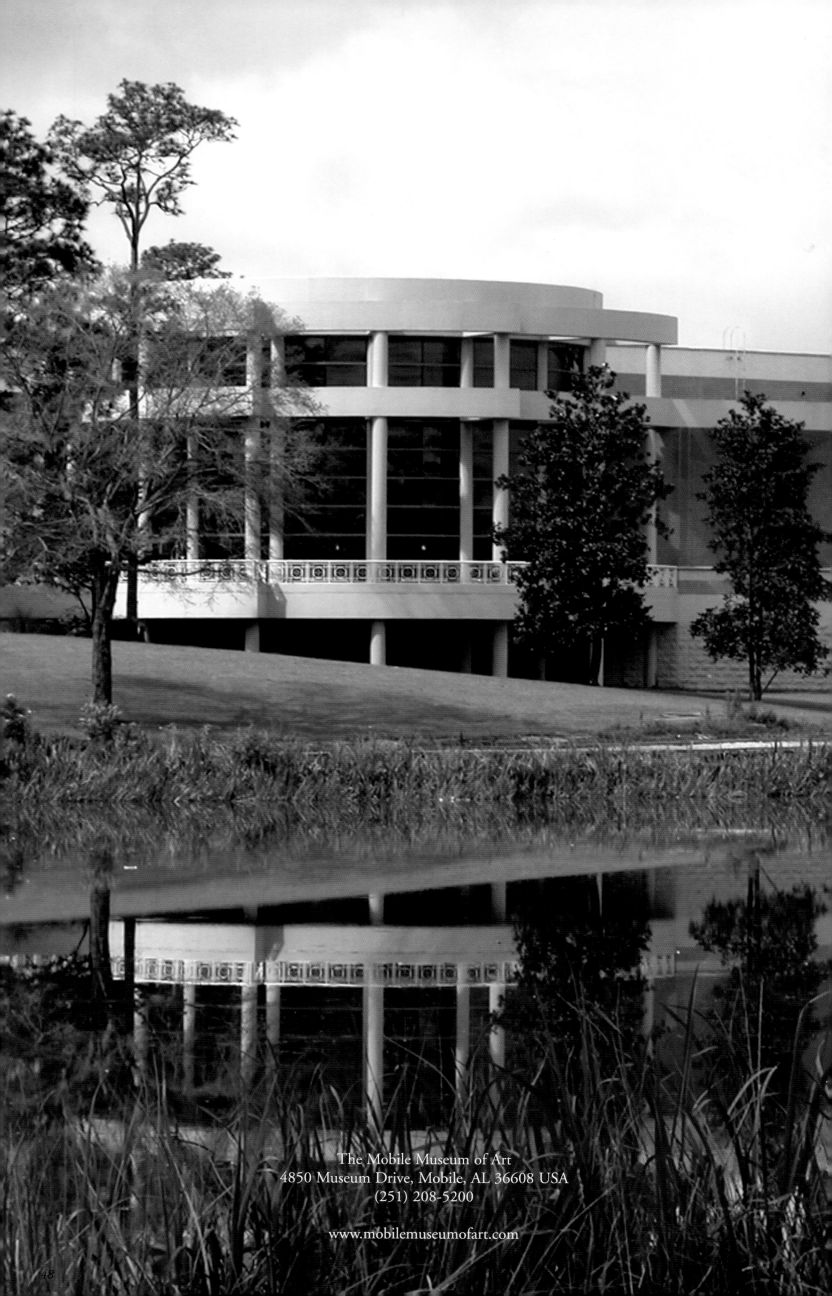

The Mobile Museum of Art
4850 Museum Drive, Mobile, AL 36608 USA
(251) 208-5200

www.mobilemuseumofart.com